C000156742

CINEMA STORIES

James Nash was born in London in 1949, and has been a resident of Leeds since 1971. He is a well-known provider of creative writing workshops in schools, universities and the community, and is regularly called on as a host of literary events. His most recent collection of poetry is *Some Things Matter: 63 Sonnets* (2012).

Matthew Hedley Stoppard was born in Derbyshire in 1985. After a brief career as a journalist, he now works as a librarian, and lives in Leeds with his wife and two sons. Recordings of Matthew's poetry include *Runt County* (Adult Teeth, 2014). His debut collection *A Family Behind Glass* was published in 2013.

Cinema Stories

JAMES NASH &

MATTHEW HEDLEY
STOPPARD

To BETH,
HOPE you LIKE
THE BOOK,

VP

Valley Press

First published in 2015 by Valley Press
Woodend, The Crescent, Scarborough, YO11 2PW
www.valleypressuk.com

First edition, first printing (October 2015)

ISBN 978-1-908853-52-3
Cat. no. VP0076

A CIP record for this book is available from the British Library.

Printed and bound in the EU by Pulsio, Paris.

www.valleypressuk.com/books/cinemastories

Contents

ACT THREE: JAMES NASH

Acknowledgements

'The Elephant's Foot' was first published online as part of the *Leads to Leeds* project.

James Nash would like to thank Kevin Hickson, for his photography; Carol Mather, for dragging him to the HPPH on Mondays for ten years; Philip French, for his inspirational *Observer* film reviews; Matthew Hedley Stoppard, for having the fabulous idea for this book; and David Robinson, for being brilliant.

Matthew Hedley Stoppard would like to thank Mick McCann, whose article on Leeds's cinematic history in *The City Talking* magazine inspired *Cinema Stories*; Robert E. Preedy, whose history and heritage books were a constant source of inspiration; Wendy Cook, for making us part of the Hyde Park Picture House's history; Peter Spafford, Jamie McGarry and James Nash for their support; and his family, for their love and patience.

This book is dedicated to Albert Morgan Nash, crusty old bugger, who loved Sunday afternoon films.

Act One

by James Nash

Forgotten temples in Woodhouse: the bike ride

Old churches spike the skyline
whereas chapels stand no nonsense,
and terraces form a respectable congregation
in the streets around the Victorian school.

I'm on my bike
searching for forgotten temples
where twentieth-century gods and goddesses
once came to life,
and flickering visions, first in black and white
and later in Technicolor,
were seen.

Sometimes you have to look up
to see the architectural leftovers
of deco, the marcel wave of concrete,
the clues of colonnades of contrasting bricks,
the turret and the geometric window
of the projection room.

And then outside a junk shop
a short flight of cinema seats leans
on the pavement,
torn red plush, the smell
of horsehair and mouse.
I run my hand across the backs,
the ashtrays and the upholstery cord,

and I am back,
fifty-five years ago,
under the single red eye of the usherette.

It is only later
cycling past Cardigan Fields,
under the railway viaduct,
that I see the temples of today;
prefabricated dream-houses,
like aircraft hangars,
the night club, pub,
multiplex and gym.

Lost Horizon (1937)

Starring: Ronald Colman, Jane Wyatt

It is our first journey together,
searching for lost horizons.

You drive and I muse aloud as we retrace a Leeds
I've known for forty years –
ten years before you were born.
The lock-gate between brain and mouth
has burst open with age
and I am flooded with memory and wittering;
for you
it must be like taking a chatty uncle
out for the day.

You resist settling a travel rug around my knees
as we drive into sleet and rain
and the surprising bright projections of winter sunlight
shining into our eyes,
between the showers.

Rio Bravo (1959) Pictureland, Armley

Starring: John Wayne, Dean Martin, Ricky Nelson

Now these buildings are in disguise:
one – recently a carpet warehouse – is masked
in a shrink-wrap of plastic sheeting;
next door, the old Pictureland
has become a launderette,
temporarily abandoned by staff and customers.
It feels like the end of the world, and probably civilization;
Christmas baubles hang with ghastly irrelevance.

Old cinema doors are still visible
though ceilings (and standards) have been lowered.

All around are admonishing notices in large print,
prohibitions about customer behaviour
addressed to us;
but I am listening out for John Wayne and Ricky Nelson
spraying the baddies with bullets in *Rio Bravo*.
Even they would not have lasted here,
been shown the door.
Their odd socks held to ransom.

Wuthering Heights (1939) The Haddon Hall, Burley

Starring: Laurence Olivier, Merle Oberon, David Niven,
Geraldine Fitzgerald, Flora Robson

Driving in decreasing circles
between Burley and Kirkstall Road
we run the Haddon Hall to earth,
measure it up against our photograph.

Now inhabited by a dance school
it once brought a different kind of romance to these streets,
terrace after terrace, in the valley
where you both worked in the local mills
and of an evening, after a mild and bitter
or port and lemon sophistication at the Cardie Arms
you might have seen Merle Oberon, beautiful but not *Cathy*,
and Laurence Olivier, an oddly well-spoken Heathcliff,
up on the moors; the real ones not so far from here.

You'd leave and cross the street for home in Argie Avenue,
and perhaps up on the ridge, on the other side of the valley,
you might imagine some wuthering –
knowing you will dream of the film
throughout the following day.

David Copperfield (1935) The Barracks, Agra / The Lyceum, Burley

Starring: Freddy Bartholomew etc. etc.

Red dust and heat beat us daily.

Here in the assembly hall,
large fans flap and stir slowly
the hot scent of Uttar Pradesh.

The barracks roast in a tandoori oven,
and we are done to a turn.

This film is not an England I know or recognise,
a Hollywood concoction,
but it will do.

As I shuffle my boots on the dirt floor
and feel sweat roll under my tunic,
I imagine walking across the
grass of Burley Park,
green even at the height of summer,
over the railway footbridge
to the Lyceum,

and can smell again
the bruised scent of an English summer,
hear the *plop* of tennis courts,
the *click* of the bowling green.

Billy Liar (1963) The Crown, Tong Road

Starring: Tom Courtenay, Julie Christie

At first I didn't recognise any of the places,
then I saw Leeds Town Hall,
reassuringly sooty,
followed by Forster Square in Bradford,
and Wellington Road in Wortley
not far from where I watched the film.

These shots were, I realised, a patchwork
of *The North*.

Tom Courtenay spoke as if he came from 'Ull,
which he does, and Julie Christie said bath
with a short 'a' like she meant it,
and she glowed through the film
with the new blonde beauty
of a Dusty Springfield or Marianne Faithful.

I was sixteen, and as I watched
it fuelled my need to escape,
not wanting Billy's broken dreams
for myself.

So I went away;
but returned not so long after,
fitted that short 'a'
back in my mouth like it belonged there,
and carried on.

Pride (2014) The Cottage Road

Starring: Bill Nighy, Imelda Staunton, Dominic West,
Paddy Considine, Andrew Scott

We sit at the front where he's always sat,
Keeping his coat on, now he feels the cold.
I look around. No, I did not forget
The cinema I came to, five years old.
He shuffles, there'll be memories stirred,
He wonders, perhaps, why he's not at home,
But when it starts he's tied to every word,
I hear him breathe, sigh – was that a moan?
At the end he seems smaller, as if he's shrunk,
Anger gone, fire out after thirty years,
But the film has reminded him, made him think
Of broken picket lines, heads, and long-past fears.
While the audience clap, a buzz of talk,
My father weeps silent tears in the dark.

The Way to the Stars (1945) The Old Palace Picture Hall

Starring: Michael Redgrave, John Mills, Rosamund John, Douglass Montgomery, Stanley Holloway, Renée Asherson

He sits and smokes and watches the film
and something like hope stirs.

He remembers when they dropped
twenty-five tons of bombs on Leeds
on that March night in '41,
taking out the museum, the old stuffed tiger,
and sixty-five innocent folk.

Home for the weekend in Aviary Street,
he'd heard the bombers overhead.
They'd sat in the basement;
he'd held young Jim and Margey,
while his mother, close-faced and toothless, had made tea
boiling a kettle on the cellar-head stove.

And they all were scared.

In this film everyone is heroic and beautiful,
but that's alright.
He leans back on the faded velvet cinema seat;
breathes in the foisty smell of home.

Cinema Clock

Keeping to Art Deco time,
its tick a foxtrot, a rustle of satin,
its face a handsome wood veneer,
curved, cocoa-coloured numbers
against the grain.
A mask of past elegance,
transferred from the Gaumont
to the Hyde Park Picture House,
to films with subtitles –
where perhaps it still dreams
of Fred and Ginger.

Cinema Dreams

Hypnotised by this moon
we sit in silvered darkness,
occasionally rustling;
a night-time consort,
who sigh and breathe
together.

Thoughts and stories flicker
across our faces,
through the lunar landscapes
of our brains,
and we sink into
dreams.

This dark wood has perfumes
which crowd in on us;
the scent on someone's coat,
a confected sweetness
in the warm air,
and you.

Blinded by a sudden dawn
we stumble to the doors
and outside
where we blink away
the darkness,
and the dreams.

Act Two

by Matthew Hedley Stoppard

Last days of the Regal

for Mum

Only ever knowing kindness, she donated
surplus breast milk to orphans the night
her eldest was born. Two daughters down

the line, this saint holding a nitcomb strived
to take her only son to the cinema as well as
reciting twelve-times-tables with him during

the bike ride to school. Outside the cloakroom,
she offered imperial mints that once mixed with
bus fares and pills for her nerves (knifed in half)

in her tabard pocket. So it's no surprise to recall
an evening when she draped her coat over
his trembling knees at a screening of *Beauty and the Beast*

the winter before the Regal shut its doors.
Rather than stop the projector running
they refused to pay the heating bill, and for a week

of showings, audiences shivered in rows
fixated on a singing candelabra reaching
a glorious note that still makes her son cry

into his bucket of popcorn, eyes streaming
like a mother's breasts teeming with milk.

Gigolo in the Carriageworks

after Miehen Tyo, Leeds International Film Festival, 2007

Most would agree it wasn't first-date viewing
and you noticing the holes in my boots
while we stood queuing
meant we were doomed from the start.

Hard chairs, and dodgems colliding
in Der Christkindlmarkt outside
almost made me suggest leaving
but the credits rolled ('A Man's Job'), subtitled.

Our office romance had finally spilled into those
makeshift cinema aisles and the bier keller
on Millennium Square – I do not dare
fathom where I'd be if it hadn't.

The scent of intense apples in your perfume
still fills my nostrils,
even though you don't wear it anymore –
I breathe it and know I'm living, not losing.

I strangely empathised with the Finnish
family man on the screen –
popping Viagra to service a quarter-tonne woman,
combing a pensioner's hair stark-bollock-naked,
crashing through a glass table dancing
for a hen party – anything to make money
for his wife and children before falling
apart like the boots I was wearing.

You wouldn't come near me
in front of your friends the rest of the evening,
but love was given back when I stole a kiss
then we went home in our respective taxis.

Song of the Matinee Usher

Follow me through the darkness and be blinded
by a world brighter than outside.
Hollywood heads, the size of Easter Island's, locking lips;
the noise of war, bullet holes and Blitz in newsreels;
all from the safety of your spring-loaded seat.

Fathers of East Leeds, rest assured your daughters
will maintain their dignity in the back row;
a hand on the knee, a peck on the cheek
and they'll feel the circle of my torch on them
like an inmate caught during a prison break.
The same goes for the culprits
of airborne popcorn kernels.

Some mock my uniform (I'm Cinderella's Buttons
or a Russian soldier), my raspberry-coloured jacket,
and white gloves, but ushers at the Bug Hutch
in Burley must wear their own clothes on duty,
and I earn more than the staff at The Star –
you couldn't ask for a better Saturday job!

On top of all this, I watch every film for free
in my periphery, and get to keep the posters for my bedroom
where the tinnitus of blockbuster dialogue
keeps me awake at night.

Ode to a Shaftesbury usherette

Cracks in the choc-ice casing
reveal vanilla and heaven inside;
she appears when newsreels are rolling,
my velvet and brass-buttoned bride.

Popcorn falls from the balcony
like confetti on the people below;
eyes raised in the hope that she sees me
dressed in my best dickie-bow.

I have no sweet tooth to speak of
(and few teeth, as a matter of fact),
but I've already bought dolly mixture,
toffee and a bag of Black Jacks.

Her youth seems to glow in the darkness
and I'm old as the damp on the walls;
in cinemas what does age matter?
Just look at Bogart and Bacall.

Put down your tray of goodies,
give away the cigarettes and spice,
we'll leave the smoky auditorium
and make a movie out of our lives.

The tram will be our gondola
and we'll float to the top of York Road,
scatter Seacroft with fairy dust
and waltz across every postcode.

Escape from the Nazis in Crossgates,
survive the grey jungle in Scholes,
walk a Yellow Brick Road in Garforth
filled with puddles and potholes.

House lights, and the picture has ended;
now she's gone in the clamour and litter.
A single bed and oblivion await me
in my home, where films do not flicker.

Notes on Pictureland, Armley

Bitter easterly winds quelled all desire to shop
for Polish sausage and lottery tickets,
forcing the townsfolk inside the pubs and cafes early
to marvel at how they'd made it this far
without a Day Rover. Observe rows of faces,

screwed up with bacon rind and missing molars,
that once gazed at Pictureland's screen,
now a laundrette, still decorated maroon and cream,
so desolate someone could garrotte his enemy
with a pair of forgotten knickers – the body

wouldn't be found for a fortnight, pockets rifled
for change amounting to a hot spin cycle.
Fingers and thumbs eager to receive ticket stubs
have been replaced by a two-pence pincer grip
best suited to denuding scratch cards on the walls

of the amusement room-cum-bingo hall-cum-auditorium
retaining that cinema-oblivion where locals
became comrades in forgetting everything outside:
the gaol's heavy shadow, a child's bike in
the pawn shop, the civil war of the Post Office queue.

'The Elephant's Foot'
(or Gaumont-Kalee Model 21, 1948)

"... I knew with perfect certainty that
I did not want to shoot him."

George Orwell, 'Shooting An Elephant'

There it stands,
khaki-coloured like an infantryman's spats,
inoperable, gathering dust in Armley Mills Industrial
 Museum,

reminiscent of WWII weaponry;
a Sherman Tank turret, stripped back,
once manned by scrawny projectionist, not hardened captain.

Its double-speed shutter
fired a sepia beam rather than anti-aircraft shells
in a cordite blast,
although it was capable of creating images of battle
on a large scale.

When I first heard its name
I remembered Orwell's essay on shooting an animal
considered machinery in Burma, where he served

as a young police officer
equipped with .44 Winchester rifle
used to take down a life weighing four tons –
hoping for a world in which cameras shoot
not guns.

The Vikings, 1958

for Joan

Lock every dolls' house door,
shoebox the teenybopper records
and shove them under the bed;
all she wants is a man to look after,
this prayer answered watching
Kirk Douglas have his left eye
pecked out by a falcon, a hollow
socket remaining, covered by leather
patch in some scenes, emptily
glaring at Janet Leigh in others.

Long ships sail across
the Shaftesbury's screen, ice-capped
mountains dwarf Leeds's landscape,
yet all she thinks of is placing
her little finger in Kirk's chin cleft,
and when Tony Curtis takes
a scram to the hero hanging
off the Northumbrian coastline
she wails, waking the snoozing
father beside her, who cradles
his daughter, secretly enjoying
the Nordic brawl over her shoulder.

We are the ABC Minors

for the members of Caring Together, Leeds

They say a hammer is handed out
　with each ticket at the Bug Hutch
to splat creepycrawlies on your seat.
The reel splits on Flash Gordon's
　　latest cliffhanger
and shadow puppets appear on the screen.

Safe from 'strange men' who loiter
in the evening, and the Dirty Mac Brigade
　　frequenting The Tatler,
girls go dizzy at the vastness of images
years before *Vertigo* is released.

A boot from behind – he's interested,
a note in your cup holder – it's marriage,
　we all sing Saturday morning's
jingle, remembered by a former yoyo
　　champion from Cookridge.

Red upside-down triangles proudly
　pinned to lapels, glowing
　　memories and cigarette stubs;
such innocence gives way
to grey hair and sore bones when we meet
at the Seniors' Cinema Club.

Seeing the light in
The Star

There's filth and grace in
a pigeon feather
sent twirling by wind
where cousins gather
for a christening
in the ground-floor church,
a kickboxing gym
upstairs when you search
this art deco urn
containing ashes
of lovers, film fans;
pigeon flight becomes
ghost of a flicker –
movie projector?

Aerial stunt over
The Regent

Burmantofts twilight
lingers like an ache
for those who catch sight
of the aeroplane.
Attendance is high
on opening night,
six block letters lie
on the roof – don't fight
the urge to raise hands,
clutch falling paper;
our spectacle and
picturehouse never
could be seen for miles;
now Al-Murad Tiles.

Prayer of an employee at Churchill's, formerly The Crescent, Beeston

This line of work wants keeping secret
but it will help me, financially.
Anticipate a Prince of England, France, Washington...
successful figures in offices out there.
I will remain yours, company for a week or two,
a couple for months – our fidelity delayed –
kept in life-like action, practically dévoué.
Otherwise, remember me to brothers
in England, France and Washington –
hoping to secure a little work out there
in a couple of months through
successful figures in offices –
this wants keeping secret till secured.

Fragments from The Late Show, Cottage Road

Beware! We've come to
give the moon back to Jesus:
he's like a wizard.

I'm sorry, my dear,
I shat in the fruit on the
Paris holiday.

Frankly, I don't like
to give my fruit to Jesus;
I am always just!

The damn fella on
the box is always one to
choose a juicy dear.

Mrs de Winter,
the lads just don't give a damn –
always my mistake.

The Lyric without James

This idea is finding
a new ticklish bodypart
and now I'm here
more aware I miss
his half-century of city
cabbies mistaking
him for a bouncer.
Doorman of our genre,
O rhythmic hulk, you've
a grandmother that shares
an East Midlands elbow
with me, umbilically
linked to my birthplace
avoiding this moment,
sunlight behind pink lettering,
the shadow of LYRIC
across my forehead looking up.

Act Three

by James Nash

Counter culture

It is 1972
and we are sitting in the Hyde Park Picture House
watching a re-run of *Easy Rider*.

Gas-mantles flicker with quiet poppings
and smoke hangs around our heads in rings
as we eat ice-cream from tubs.

I am resplendent in cheese-cloth shirt and purple loons
(you can Google them)
and my girlfriend wears a suede jacket with cowboy fringing.

We consider ourselves to be ineffably cool,
unable to see just how young we are
as we passively breathe in the counter-culture.

Only afterwards, blinking in the afternoon sunshine
do we realise how deeply and irretrievably
are we stoned.

Gooseberry (1994) The Lounge, Headingley

They ask me to go to the cinema with them,
and I go, touched that as a couple
they are prepared to share.

I sit with them,
all of us munching and chatting,
not feeling at all like a gooseberry
until the film starts
and they somehow get closer,
and while they are watching
occasionally touch each other on the leg.

It looks nice, friendly even;
I consider for a moment just joining in,
putting my hand on one of their knees,
but stop myself just in time.
Then I look at the legs of strangers down the row
and wonder whether they would like it.
It could be a bit of an ice-breaker.

But I rein myself in;
and instead touch one of my own legs,
and rub it lightly in a clockwise direction.
It feels surprisingly good;
but just in case anyone is looking,
I pat my leg fiercely
and stamp my foot down hard
as if I've got
pins and needles.

Sitting Room Cinema

I am in a cyclone of heat and steam
but beneath my hand the deck holds firm
while I steer my family through the storm;
here a shirt-tail and there a sleeve.
Hot metal glides and cotton is tamed,
as I press the sails for them to leave.

We wait for the film to come on soon,
and for once his face is not stiff with pain;
his heart does not seem to rage or grieve
in these two hours each Sunday afternoon.
In half-darkness they watch the screen,
and wriggle in a boiled sweet cocoon.

The screen turns from oyster grey
to black and white; when pictures appear,
that's when we've forgotten if it's night or day.
Films I first saw in the Lounge or Lyceum;
I hope for Westerns, dread those films of war
when he knocks out his pipe and leaves the room.

Now our children are grown up and gone,
and often we choose to walk arm in arm
to the Shaftesbury for whatever's on.
I swear sometimes I see a metal gleam
in the darkness at the edge of the screen;
an ironing board, standing on its own.

The old man next to me seems free of pain,
no longer dodging bullets at his age.
I sigh, suck boiled sweets (some things remain),
and push down hard with liver-spotted rage,
remembering the clouds of heat and steam,
the sails I pressed for them to leave.

Rising in the East

Are there simply too many to record
on our Sunday morning journey into the east?
I worry that we can't name-check every one,
can't capture all the dreams that used to tremble in the light
before their death,
projected through the smoke, the huddled steam of breath.

Then we travel through a seventies muddle of over- and
 under-pass
which must have seemed the last word in modernism,
but were actually its dying squeaks; drink in the deco stucco
of The Star, The Clock, The Shaftesbury for the real thing.

The Star

Here's The Star, now partly a church
which offers healing,
partly a gym and a shuttered shop,
partly an off-licence, no longer dispensing.
There is much graffiti devoted to Billy
an epic, local figure it seems,
though I have my suspicions
most of it was written by Billy.

The top of the building's a stork's nest
of radio antennae and masts.
Below, a Taj Mahal, with contrasting bands of brick
raised not to memory of film, but to its future;
now scattering plaster like dandruff,
rotting windows. Scrofulous.

But its architectural ambition tells us something
of past audiences, and how they read the world.
We shiver, uneasy tourists in a shattered land,
before climbing into the car and driving on.

That'll Be the Day (1973) The Shaftesbury,
York Road

Starring: David Essex, Rosemary Leach, Ringo Starr

The prince has long since left these apartments,
no ceremonial, be-ribboned guard in the doorway,
where only cigarette butts gather.
No cursory condoms –
too chilly perhaps, too illumined by headlights?

Spirits may well haunt the inauspicious Ibiza bar.
The cafes offer full English,
the pawn shops DO£H and CA$H,
and the pedestrian bridge
(joining Osmondthorpe to Harehills
that no-one seems to use,
and which, in its vertiginous journey, is too high for me)
is a broken spear flung against its walls,
which sink shabbily into the background.

The Shaftesbury was a different bridge perhaps,
temporal,
to other lives and tales.

The Regent (soz Shelley, apols)

The only building of its age to be seen,
Fifty years – older – possibly sixty.
A baby wheels past with a toothless beam,
Dribble-goggling at my antiquity.
Lo, Ozymandias, king of kings
This his Regent, now tile emporium,
But even as I gaze my heart sings
To an organ echo or harmonium.
It's still here amongst all the town planning,
Burgeoning trees, the acres of grass.
This mirror to me is quite unmanning,
It's still hanging on, through what came to pass.
I look on this building, its mute appeal,
Say: *Don't worry chum, I know how you feel.*

A Villanelle for The Clock Cinema

The Clock is for sale: its time has run out
Though in truth exhausted some years ago.
We must love the loss that hollows us out.

Grand illusions, reduced to a dusty rout.
Film rips across the screen, sprocket-holes show,
The Clock is for sale: its time has run out.

We've all been robbed, left shocked and without,
Tried to hold on and then had to let go.
We must love the loss that hollows us out,

For changes must come, whatever we shout.
Torn celluloid flaps, screen's long lost its glow,
The Clock is for sale. When time has run out

Some things struggle on, some things come to nowt.
Our hearts must break, for other loves to grow,
As we learn to love what hollows us out.

Old deco palace, your future in doubt,
Though in truth exhausted some years ago.
The Clock is for sale: now time has run out.
No choice but to love what hollows us out.

The Writer Visits

A sacerdotal hush before it starts.
We're ageing priests wedded to older ways
With no drugs to pump love into our hearts,
Just gypsy creams and tea to mark our days.
I talk about the cinemas of Leeds
And eyes look up, as interest piques,
As if no barrier of time impedes,
And one by one each person speaks.
The very picture houses of which I tell
Are the ones they went to years before.
At Haddon Hall, one remembered well,
Trapeze; it was difficult to ignore
How, with his trunks quite tight and worn low-slung,
Tony Curtis not just cute, but well-hung.

We will always have Paris

This no monument or mausoleum
For idle gawpers with a bit of cash,
No Pompeii or Herculaneum,
Dogs and people charred and turned to ash;
First a cinema, lately a launderette,
And now a 'commercial opportunity',
Estate agents' language shows no regret
That folk stopped leaving their houses to see
Their old gods, or do their weekly wash.
But in some future bar, or sleazy club
Someone might sense the silken smash
Of walking through a grey and whispering web
And hear – through chatter and the sounds of now –
'We will always have Paris', murmured low.

Lumber

The crab-like, furniture-moving shuffle
imposed on us
by necessity and tradition, is inescapable
as we load and unload our yoked pair of cinema seats
to take them round the city.
We will later pose them near old picture-houses
for the bearded photographer;
for now, they sit in a little park where dog poo jostles Coke
 cans
while buses pass
and walls are strung with graffiti.

We are not famous, nor were we meant to be;
children look at us momentarily in case we are
but we have none of the distinguishing features of fame or
 wealth
so their gaze slides over us, unwinking
as the eyes of fish on slabs.
And besides we are old (sorry Matthew).
Nobody *old* is famous
apart from the Queen
and she's hardly ever on Facebook or Twitter.

As we fill the car again
with our awkward, velvety burden
I am reminded of all the house removals
I have ever done,

the emptying of lumber from attics and cellars,
the rearranging in new rooms,
the looking at it all again,
making sense of it,
words and furniture in the fresh order
of their new home.

Notes on the text

JAMES NASH:

p.19 'Foisty' is a Yorkshire word meaning fusty or musty.

p.50 'Sacerdotal' is another word for 'priestly', relating to priests or the priesthood.

MATTHEW HEDLEY STOPPARD:

p.33 A 'scram' is a type of short viking sword.

p.35 These two 'skinny sonnets' constitute one complete (albeit surreal and incoherent) sonnet when placed next to each other. I thought I was the first person to do this, but the very talented York-based poet Steve Nash beat me to the punch with his poem 'Twins' in his book *Taking The Long Way Home*.

p.36 This poem was entirely composed of text from an extract of Louis Le Prince's letter featured in Christopher Rawlence's biography *The Missing Reel*. Churchill's is a brothel, which changes its name to Winston's (and back again) every few years.

p.37 This poem was composed from ten movie quotes, proffered by patrons of the Cottage Road Cinema.

p.38 The Lyric on Tong Road, Armley operated as a cinema for 66 years. At time of writing, James Nash has operated as a human being for the same amount of time. This poem is 66 words long (or short, depending on your disposition).